THE THEATRE AND OPERA-LOVER'S QUOTATION BOOK

The Theatre and Opera-Lover's Quotation Book

A Literary Bouquet

Edited by
JOYCE AND MAURICE LINDSAY

ROBERT HALE · LONDON

ISBN 0 7090 5094 1

Robert Hale Limited
Clerkenwell House
Clerkenwell Green
London EC1R 0HT

5 7 9 10 8 6

Photoset in Goudy by
Derek Doyle & Associates, Mold, Clwyd.
Printed and bound by
WBC Ltd., Bridgend, Mid Glamorgan.

Preface

veryone who comes before the public must expect to be criticized; by audiences, who have personal likes and dislikes; by fellow performers, who may dislike comparison or competition; and by critics, who are supposed to be experts and sometimes really are. So far as opera is concerned, some find it the highest expression of human art, others a veritable farrago of artifice and absurdity. Playwrights and composers, too, have their likes and dislikes, often based on clashes of creative personality. Truly, for a variety of reasons, in the theatre, as Bernard Shaw once remarked, there is 'no turn unstoned'.

What we have done is to gather together a nosegay of witty insults, a bouquet of praise and blame, amusingly displayed, the blame usually tending to be more amusing than the praise. Our sole purpose has been to divert and entertain those who love (or hate) the theatre in any of its guises. Unlike W.C. Fields, who once said: 'I am free of all prejudice. I hate everyone equally', our freedom of prejudice takes the form of relishing the witty observation for its own sake, whether or not we agree with the truth of its implications. So, slightly to misquote Noël Coward, all

you have to do now is read the lines and don't trip over the furniture!

We would like to thank all those who freely gave permission for the inclusion of copyright material; also, the Society of Authors for permission to use the Bernard Shaw quotations and Lady Lancaster and Messrs John Murray for the use of the cartoon by the late Osbert Lancaster on page nine.

Our thanks are due to the staff of the Mitchell Library, Glasgow, for help in tracing several recondite quotations, and to our friend Fran Walker for numerous helpful suggestions.

JOYCE AND MAURICE LINDSAY

The Theatres – those Cages of Uncleanness, and public Schools of Debauchery.
ST AUGUSTINE

The Theatre is a sewer!
JOHN S. SUMNER, Head of the Society for the Suppression of Vice, New York, 1922

The theatre is irresistible: organise the theatre.
MATTHEW ARNOLD
Irish Essays, The French Play in London

It is a most unholy trade.
HENRY JAMES

7

To write for low, ill-informed, and conceited actors, whom you must please, for your success is necessarily at their mercy, I cannot get away with. How would you ... relish being the object of such a letter as Keats wrote t'other day to a poor author who, though a pedantic blockhead, had at least the right to be treated as a gentleman by a copper-based twopenny tearmouth rendered mad by conceit and success. [As to London audiences] one half come to prosecute their debaucheries, so openly it would degrade a bagnio. Another set to snooze off their beef-steaks and port wine; a third are critics of the fourth column of the newspaper; fashion, wit, or literature, there is not; on the whole, I would far rather write verses for mine honest friend *Punch* and his audience.
> SIR WALTER SCOTT
> in a letter to Joanna Baillie, 1818

The play's the thing.
> WILLIAM SHAKESPEARE
> *Hamlet*

Drama is action, sir, action and not confounded philosophy.
> LUIGI PIRANDELLO
> *Six Characters in Search of an Author*

All tragedies are finish'd by a death,
All comedies are ended by a marriage.
> LORD BYRON
> *Don Juan*

Farce is nearer tragedy in its essence than comedy is.
SAMUEL TAYLOR COLERIDGE
Table Talk, 1833

Tragedy is restful; and the reason is that hope, that foul, deceitful thing, has no part in it.
JEAN ANOUILH
Antigone, 1942

The reason why Absurdist plays take place in No Man's Land with only two characters is mainly financial.
ARTHUR ADAMOV
in a speech at Edinburgh, 13 September 1962

One of the best tips for writing a play is 'never let them sit down'. Keep the characters buzzing about without a pause.
P.G. WODEHOUSE
Performing Flea

Writing a play is the most difficult thing a writer can do with a pen.
KENNETH TYNAN
Time and Tide, 1964

My dear Sir, I have read your play. Oh my dear Sir. Yours faithfully —
HERBERT BEERBOHM TREE to an aspiring dramatist

Plays, gentlemen, are to their authors what children are to women: they cost more pain than they give pleasure.
PIERRE-AUGUSTIN CARON de BEAUMARCHAIS
Preface to *The Barber of Seville*, 1775

A perfect tragedy is the noblest production of human nature.

JOSEPH ADDISON
The Spectator, No. 39

We English are more violent than we allow ourselves to know. That is why we have the greatest body of dramatic literature in the world.

JOHN OSBORNE

Great theatre is very difficult to accomplish. Only Greece, England, France and Norway have provided Europe with a great innovating theatre.

ANDREW CRUIKSHANK
Scottish Bedside Book

It has often been repeated that the Kirk killed the theatre in Scotland. This is not strictly true. The Establishment has always tried to censor the theatre everywhere, whether in Greece, Rome, England or France. The fact is that the

theatre by its ingenuity has managed to circumvent censorship.

ANDREW CRUIKSHANK
Scottish Bedside Book

I didn't like the play, but then I saw it under adverse circumstances – the curtain was up.

GROUCHO MARX

You can make a sordid thing sound like a drawing room comedy. Probably a fear we have of facing up to the real issues. Could you say we were guilty of Noel Cowardice?

PETER de VRIES
Comfort Me with Apples

English plays,
Atrocious in content,
Absurd in form,
Objectionable in action,
Execrable English Theatre!

JOHANN WOLFGANG von GOETHE, 1749

There is a total extinction of all taste: our authors are vulgar, gross, illiberal; the theatre swarms with wretched translations, and ballad operas, and we have nothing new but improving abuse.

HORACE WALPOLE

15 Novembris 1681, being the Queen of Britain's birthday, it was kept by our Court at Holyrood House Edinburgh with great solemnity, such as bonfires, shooting of cannons, and the acting of a comedy called *Mithridatus King of*

Pontus, wherin Lady Anne, the Duke's daughter, and the Ladies of Honour, were the only actors.
> LORD FOUNTAINHALL
> *Observing* (probably Racine's *Mithridate*, the 'Lady Anne' being the future Queen Anne)

I saw *Hamlet Prince of Denmark* played, but now the old plays begin to disgust this refined age.
> JOHN EVELYN
> *Diary*, 26 November 1661

And Hamlet, how boring, how boring to live with,
So mean and self-conscious, blowing and snoring,
His wonderful speeches, full of other folk's whoring!
> D.H. LAWRENCE
> 'When I Read Shakespeare'

The stage can be defined as a place where Shakespeare murders Hamlet and a great many Hamlets murdered Shakespeare.
> ANON

Hamlet is not a role that an actor should ever be asked to portray for a hundred performances on end.
> JOHN GIELGUD

To the King's Theatre, where we saw *Midsummer Night's Dream*, which I had never seen before, nor shall ever again, for it is the most insipid, ridiculous play that ever I saw in my life.
> SAMUEL PEPYS
> *Diary*

After dinner to the Duke's house, and there saw *Twelfth Night* acted well, though it be but a silly play.
> SAMUEL PEPYS
> *Diary*, January 1663

A strange, horrible business but I suppose good enough for Shakespeare's day.
> QUEEN VICTORIA on *King Lear*
> H. Thomas in *Living Biographies of Famous Rulers*

If it be true that 'good wine needs no bush',
'tis true that a good play needs no epilogue.
> WILLIAM SHAKESPEARE
> *As You Like It*

This litter of epithets [John Dryden's *The Spanish Friar*] make the play look like a bitch over-stocked with puppies, and sucks the sense almost to skin and bone.
> JEREMY COLLIER, 1698

At Drury lane we were threatened with a version of *La Dame aux Caméllias*, but the Lord Chamberlain refused a licence to this unhealthy idealization of one of the worst evils of our social life. Paris may delight in such pictures, but London, thank God!, has still enough instinctive repulsion against pruriency not to tolerate them.
> G.H. LEWES
> *The Leader*, April 1853

After all, what was *Medea*? Just another child custody case.
> FRANK PIERSON

These Ibsen creatures [in *Romersholm*] are 'neither men nor women, they are ghouls', vile unlovable, morbid monsters, and it were well indeed for society if all such went and drowned themselves at once.

> *The Gentlewoman*, 1891

If you were to ask me what *Uncle Vanya* is about, I would say about as much as I can take.

> ROBERT GARLAND
> *Journal America*, 1946

All that Russian gloom and doom, and people shooting themselves from loneliness and depression and that sort of thing. But, then, mother says I don't understand comedy. I expect she's right.

> SIMON GRAY
> *Quartermayne's Terms*

The limit of stage decency was reached last night ... in the performance of one of Mr George Bernard Shaw's 'unpleasant comedies', *Mrs Warren's Profession* ... The play is an insult to decency because:

It defends immorality

It glorifies debauchery

It besmirches the sacredness of the clergyman's calling

It pictures children and parents living in calm
observance of most unholy relations

If New York's sense of shame is not aroused to hot indignation at this theatrical insult, it is indeed a sorry plight.

> NYM CRINKLE
> New York Herald, 1902

It has not vitality enough to preserve it from putrefaction.
SAMUEL JOHNSON of Sheridan's *The Rehearsal*
James Boswell, *Life of Johnson*

Now that you've got me right down to it, the only thing I
didn't like about *The Barretts of Wimpole Street* was the play.
DOROTHY PARKER
New Yorker, 1931

Tea is the most usual meal on the stage, for the reason that
it is the least expensive, the property lump of sugar being
dusted and used again on the next night.
A.A. MILNE
The Sunny Side

If you want to get up and stretch your legs, best do it now.
We've a play by Plautus next – and it's a long one!
PLAUTUS in one of his prologues

The delights – the ten thousand million delights of a
pantomime.
CHARLES DICKENS

The big-bosomed, broad-buttocked, butcher-thighed race.
JAMES AGATE
on Victorian Principal Boys

Pretty dancers and a pleasant company all rehearsed
together, and gradually the star, Fred Emney, the fat,
gentleman comic and the dame, Henry Lytton Junior, got
their acts together and we all launched into the dress
rehearsal wearing the usual old medieval pantomime
costumes. During the run, I learned some gags and absorbed

the pantomime method. The story was extremely thin ... but there were plenty of laughs and excitement ... Some nights it was my turn to sit in the auditorium as one of the punters and interrupt Fred Emney.

'Any requests, please?' he would call.

'Yes, d'you know *The Little Sheep on the Mountain?*' I would respond.

'How does it go?'

'Baaa! Baaa!'

> CLIVE DUNN
> *Permission to Speak*

Everybody pooh-poohs the pantomime, but everybody goes to see it. It is voted 'sad nonsense' and plays every night for two months.

> *The Times*, December 1823

The act of being funny is the hardest job in the world.

> BILL BRYDEN
> quoted by Beryl Reid in *So Much Love*

Happy is the country which has no history, and happier still is that musical comedy about which one can find nothing to say.

> JAMES AGATE
> *Sunday Times*, 1920

There flows through this form of entertainment a stream of mindlessness.

> JAMES AGATE
> *Sunday Times*, 1928

Mr Coward cannot compose and should sing only for his friends' amazement.

> *Sunday Express* critic on Noël Coward after the first night of *London Calling*, quoted in Sheridan Morley's *Gertrude Lawrence*

No, No, Nanette is trivial, banal, mendacious and stupid beyond the rights of any show however escapist, to be in this day and age ... One does not come out humming 'Tea for Two', one runs out pursued, bugged, hummed by it ...

> JOHN SIMON
> on a 1960s revival

The aim of the music-hall is, in fact, to cheer the lower classes up by showing them a life uglier and more sordid than their own.

> MAX BEERBOHM
> *Saturday Review*

I lift my hat to Mr Novello. He can wade through tosh with the straightest face: the tongue never visibly approaches the cheek.

> IVOR BROWN
> *Observer*, 1935

Miss Phyllis Dixie is again stationed at the Whitehall Theatre. She calls herself 'England's popular pin-up girl' but her share of the entertainment seems largely to be due to unpinning ...

> *Observer*, 1944

Positively the worst revue I have ever seen ... Let me not weary you with details, but I cannot recall a moment when I was not yearning to be released from my seat.

> MILTON SHULMAN on *Not to Worry*
> *Evening Standard*, 1962

[On the same production] In the 1930s there was a revue that was so bad that on the first night the management did not raise the curtain after the interval. They showed no such leniency last night.

> ANON

The cause of plagues is sin, if you look to it well; and the cause of sin are plays; therefore the cause of plagues are plays.

> THOMAS WHITE (1550-1624)

Murderous topics are always congenial to the dramatist.

> SIR SYDNEY LEE, on Thomas Kyd
> *Dictionary of National Biography*

Shakespeare, Madam, is obscene and, thank God, we are sufficiently advanced to have found it out.

> FRANCES TROLLOPE
> quoting an American

If Shakespeare's genius had been cultivated, those beauties which we so justly admire in him would have been undisgraced by those extravagancies and that nonsense with which they are so frequently accompanied.

> EARL OF CHESTERFIELD
> *Letters*, 1764

There is in this play [*Othello*] some burlesque, some humour and ramble of comical wit, some show, and some mimicry to divert the spectators: but the tragical part is plainly none other than a bloody farce; without salt or savour.
THOMAS RYMER
A Short View of Tragedy, 1692

Give me *The Winter's Tale*, 'Daffodils that come before the swallow dares', but not *King Lear*. What is King Lear but poor life staggering in the fog?
OSCAR WILDE
recalled by W.B. Yeats when they met at a party
given by W.E. Henley

There is something so wild, and yet so solemn in his speeches of ghosts, fairies, witches and the like imaginary persons, that we cannot forbear thinking them natural, though we have no rule by which to judge of them, and must confess, if there are such beings in the world, it looks highly probable as if they should talk and act as he has represented them.
JOSEPH ADDISON
Spectator, 1 July 1712

When I read Shakespeare I am struck with wonder
That such trivial people should muse and thunder
In such lovely language.
D.H. LAWRENCE
'When I read Shakespeare'

Shakespeare's name, you may depend upon it, stands absurdly too high and will go down. He had no invention as

21

Shakespeare and the Pygmies

to stories, none whatever. He took all his plots from old novels, and threw their stories into dramatic shape ... That he threw over whatever he did write some flashes of genius, nobody can deny; but this was all.

 LORD BYRON
 in a letter to James Hogg, 24 March 1814

The fact is, we are growing out of Shakespeare. Byron declined to put up with his reputation at the beginning of the nineteenth century; and now, at the beginning of the twentieth, he is nothing but a household pet.

 BERNARD SHAW
 Saturday Review, 11 July 1890

This enormous dunghill.

 VOLTAIRE
 in a letter to d'Argental, 19 July 1776

He is fair game, like the Bible, and may be made use of nowadays even for advertisements of soap and razor.

 RALPH VAUGHAN WILLIAMS
 Preface to *Sir John in Love*

I have tried lately to read Shakespeare, and found it so intolerably dull that it nauseated me.

 CHARLES DARWIN
 Autobiography, 1860

One of the greatest geniuses that ever existed, Shakespeare, undoubtedly wanted taste.

 HORACE WALPOLE, 4th Earl of Oxford
 in a letter to Wren, 1764

If we wish to know the force of human genius we should read Shakespeare. If we wish to see the insignificance of human learning we may study his commentators.

> WILLIAM HAZLITT
> *On the Ignorance of the Learned*, 1821

The remarkable thing about Shakespeare is that he is really very good – in spite of all the people who say he is very good.

> ROBERT GRAVES
> overheard remark, 1964

Shakespeare was not of an age, but for all time.

> BEN JONSON

Do you know how they are going to decide the Shakespeare–Bacon dispute? They are going to dig up Shakespeare and dig up Bacon; they are going to get Tree [the actor Beerbohm] to recite *Hamlet* to them. And the one who turns in his coffin will be the author of the play.

> SIR WILLIAM SCHENK GILBERT
> *Letters*

Whatever Sheridan has done or chosen to do has been *par excellence* the best of its kind. He has written the best comedy (*The School for Scandal*), the best opera (*The Duenna*), the best farce (*The Critic*) and the best address (*The Monologue on Garrick*) and to crown all, delivered the best oration (the famous Begum speech) ever conceived or heard in this country.

> LORD BYRON

The gods have given me almost everything. I had genius, a distinguished name, high social position, brilliancy, intellectual daring: I made art a philosophy and philosophy an art: I altered the minds of men and the colour of things: there was nothing I said or did that did not make people wonder. I took the drama, the most objective form known to art, and made it as personal a mode of expression as the sonnet, and at the same time I widened its range and enriched its characterisation: drama, novel, poem in rhyme, poem in prose, subtle or fantastic dialogue, whatever I touched I made beautiful in a new mode of beauty ... I summed up all systems in a phrase, and all existence in an epigram.

OSCAR WILDE
in a letter to Lord Alfred Douglas, 1897

The three women I have most admired are Queen Victoria, Sarah Bernhardt and Lillie Langtry. I would have married any one of them with pleasure.

OSCAR WILDE
quoted by Vincent O'Sullivan in *Letters of Oscar Wilde* (footnote)

That sovereign of insufferables.

AMBROSE BIERCE
Wasp, 1882

He was, on his plane, as insufferable as a Methodist on his.

H.L. MENCKEN
Introduction to Wilde's *A House of Pomegranates*

When Oscar came to join his God,
Not earth to earth, but sod to sod,
It was for sinners such as this
Hell was created bottomless.
> ALGERNON SWINBURNE
> 'Oscar Wilde'

The solution that, deliberately or accidentally, he found was to subordinate every other dramatic element to dialogue for its own sake and create a verbal universe in which the characters are determined by the kinds of things they say, and the plot is nothing but a succession of opportunities to say them.
> W.H. AUDEN
> *Forewords and Afterwords*

Oscar Wilde looked, according to a contemporary, like a Roman Emperor carved out of suet.
> ANON

Ladies and Gentlemen: I have enjoyed this evening immensely. The actors have given us a charming rendering of a delightful play, and your appreciation has been most intelligent. I congratulate you on the success of your performance which persuades me that you think as highly of the play as I do myself.
> OSCAR WILDE
> curtain speech after the performance of his first
> comedy, 20 February 1892

It is written by a butterfly for butterflies.
> OSCAR WILDE
> to Arthur Humphreys à propos *The Imp*

I want to put on stage life as it really is, people as they really are, and not stilted.
ANTON CHEKHOV

The chief thing, my dear fellows, is to play it simply, without any theatricality: just very simply. Remember that they are all ordinary people.
ANTON CHEKHOV
at a rehearsal of *The Seagull*

Anton Pavlovich [Chekhov], Shakespeare's plays are very bad, but yours are worse.
attributed to LEO TOLSTOY

I do not believe in simple characters on stage ... My souls are conglomerations from past and present stages of civilization; they are excerpts from books and newspapers, scraps of humanity torn from festive garments which have become rags – just as the soul itself is a piece of patchwork.
AUGUST STRINDBERG

George too Shaw to be God.
DYLAN THOMAS
in a letter to Pamela Hansford Johnson, October 1933

He went through the fiery furnace, but never a hair was missed
From the heels of our most Colossal Arch-Super Egotist.
Punch, March 1917

The noisiest of all old cocks.
> D.H. LAWRENCE on Shaw

I must say Bernard Shaw is greatly improved by music.
> T.S. ELIOT on being asked by Rex Harrison for his
> opinion of *My Fair Lady* on the opening night
> *New York Times*, 2 December 1956

There is at least one outstanding fact about the man we are studying: Bernard Shaw is never frivolous. He never gives his opinions a holiday: he is never irresponsible even for an instant. He has no nonsensical second self which he can get into as one gets into a dressing-gown; that ridiculous disguise which is yet more real than the real person.
> G.K. CHESTERTON
> 'Shaw the Puritan', *Essays*

Shaw is a puritan who missed the *Mayflower* by five minutes.
> BENJAMIN de CASSERES
> *Mencken and Shaw*

Mr Bernard Shaw has no enemies, but is intensely disliked by all his friends.
> OSCAR WILDE
> quoted by W.B. Yeats in *Autobiographies*

The way Bernard Shaw believes in himself is very refreshing in these atheistic days when so many people believe in no God at all.
> ISRAEL ZANGWILL

How can you write a play of which the ideas are so significant that they will make the critic of *The Times* get up in his stall and at the same time induce the shop girl in the gallery to forget the young man who is holding her hand?
SOMERSET MAUGHAM
Cakes and Ale, 1930

I am not interested in the ephemeral – such subjects as the adulteries of dentists. I am interested in those things that repeat and repeat and repeat in the lives of the millions.
THORNTON WILDER
New York Times, 6 March 1961

1935 *Punch* cartoon: 'I heard the dear child sobbing during my death-scene.'
'Yes, she found that her chocolates all had hard centres.'

As to the matter of my dramas, while I defer, naturally, to your enormous knowledge of the business, I still remember that what one man thinks funny another thinks imbecile; that what St Paul was excited about, the intelligent Greeks thought foolishness ...

> JAMES BRIDIE to St John Irvine, drama critic of the *Observer*, 3 December 1936

... When you class me with the bruised and whining ones, you lie, London has treated me very well indeed, considering that it hasn't the faintest idea what, if anything, I am talking about.

> JAMES BRIDIE
> to St John Irvine, 5 June 1939 quoted in *A Scottish Postbag*, ed. Bruce and Scott

I sat through the first act [of *Marriage is no Joke*] and heard my lovely lines falling like cold porridge on a damp mattress.

> JAMES BRIDIE
> *One Way of Living*

I do not like first nights. Nobody does, except those who go regularly to see and be seen at them. There is no more disagreeable noise than the babel they set up in the foyer two minutes before the curtain is due to rise. But they are not so black as they are painted. I find that if I have a couple of whiskies and sodas I can sit through the piece in my stall with an impudent face and laugh brazenly at my own jokes.

> JAMES BRIDIE
> *One Way of Living*

When I was good, I was very, very good ... when I was bad, we folded.

NEIL SIMON, US playwright

Much of the contemporary English polite comedy-writing suggests a highly polished and very smooth billiard table with all the necessary brightly-polished cups, but without balls.

GEORGE JEAN NATHAN
Vanity Fair, c.1935

Joyce was a synthesizer, trying to bring in as much as he could. I am an analyzer, trying to leave out as much as I can.

SAMUEL BECKETT
New York Times, 19 April 1981

I'm in the business of providing people with secondary satisfactions. It wouldn't have done me much good if they had all written their own plays, would it?

J.B. PRIESTLEY at 89
Illustrated London News, September 1984

Some writers take to drink, others take to audiences.

GORE VIDAL
New York Times, 12 March 1981

My greatest trouble is getting the curtain up and down.

T.S. ELIOT
Time, 6 March 1950

All the world's a stage,
And all the men and women merely players;
They have their exits and their entrances;
And one man in his time plays many parts.
 WILLIAM SHAKESPEARE
 As You Like It

Their hands demand and promise; they summon and dismiss; they translate horror, fear, joy, sorrow, hesitation, confession, repentance, restraint, abandonment, time and number. To suggest illness, they imitate the doctor feeling the patient's pulse; to indicate music they spread their fingers in the fashion of a lyre.

 QUINTILLIAN, 1st century A.D., on the players

Some transform and transfigure their bodies with obscene dance and gesture, now indecently unclothing themselves, now putting on horrible masks.

 medieval clergy on actors
 quoted in Ronald Harwood's *All the World's a Stage*

What tumult! What satanic clamour! What diabolic dress!
Here are to be seen naught but fornication,
adultery, courtesan women,
men pretending to be women and soft-limbed.
 15th-century Fathers on the boys' theatre
 quoted in Ronald Harwood's *All the World's a Stage*

Stage-players ... are sinfull, heathenish, lewd, ungodly Spectacles and most pernicious Corruptions, condemned in all ages as intolerable Mischiefes to Churches, to Republickes, to the manners, mindes and soules of men.

And that the Profession of Play-poets, of Stage-players; together with the penning, acting and frequenting of Stage-players are unlawfull, infamous and misbeseeming Christians.

WILLIAM PRYNNE (1600-69)

We players are a set of merry, undone dogs, and though we often want the means of life we are seldom without the means of mirth. We are philosophers and laugh at misfortune: even the ridiculous situations we are sometimes

At the French Play
Incognito secured – blushes concealed – and self-respect preserved
(at least outwardly).

placed in, are more generally the cause of mirth than misery.

S.W. RYLEY
The Itinerant, 1808

All sorts of people come here at times – gentlemen as well as actors. I didn't know which you was, sir, for the moment.

HORACE WYNDHAM
The Flare of the Footlights

I love acting. It is so much more real than life.

OSCAR WILDE
The Picture of Dorian Gray

Question: Do actors need brains?
Answer: If they can act, no. If they can't, yes.

JAMES AGATE
The Latter Ego

The actor – a paradox who plays when he works and works when he plays.

Toasts for All Occasions, ed. Lewis C. Henry

You can pick out actors by the glazed look that comes into their eyes when the conversation wanders away from themselves.

MICHAEL WILDING

It is a great help for a man to be in love with himself. For an actor, it is absolutely essential.

ROBERT MORLEY
Playboy, 1979

Players, Sir! I look upon them as no better than creatures set upon tables and joint stools to make faces and produce laughter, like dancing dogs.

SAMUEL JOHNSON
in a letter to James Macpherson, 1775

Playing Shakespeare is so tiring. You never get a chance to sit down unless you're a king.

Time, 16 November 1953

Acting is a masochistic form of exhibitionism. It is not quite the occupation of an adult.

LAURENCE OLIVIER
Time, 3 July 1978

Actors cannot see the audience, so develop sense for the slightest sound. They are familiar with every cough, gasp and sneeze, whoopsnort and snizzle and all the drips and wheezes that flesh is heir to.

> SIR RALPH RICHARDSON
> quoted in *The Guinness Book of the Theatre*

'Acting,' Sir Ralph Richardson of the Old Vic pronounced last week, 'is merely the art of keeping a large group of people from coughing.'

> *New York Herald Tribune*, 19 May 1946

Actors are like racehorses. You just rein them in or whip them on and make sure you give them a lump of sugar if they do well.

> TERRY HANDS
> quoted in *The Guinness Book of Records*

Every actor in his heart believes everything bad that's printed about him.

> ORSON WELLES

At one time I thought he wanted to be an actor. He had certain qualifications, including no money and a total lack of responsibility.

> HEDDA HOPPER
> *Under My Hat*

Do not confound an aphrodisiacal actress with a talented one.

> GEORGE JEAN NATHAN
> *American Mercury*

Actresses will happen in the best-regulated families.
OLIVE HERFORD

We used to have actresses trying to become stars; now we have stars trying to become actresses.
attributed to SIR LAURENCE OLIVIER

I got all the schooling any actress needs. That is, I learned to write enough to sign contracts.
HERMIONE GINGOLD

For though we actors one and all agree
Boldly to struggle for our vanity,
If want comes on, importance must retreat;
Our first great ruling passion – is to eat.
DAVID GARRICK
his apology for producing a pantomime, *Queen Mab*

Actors must practise restraint, else think what might happen in a love scene.
SIR CEDRIC HARDWICKE

If you don't know actors well, they do always eat as if it's the very last meal they are ever going to have, and quite right too! It's not that we're greedy; you see, we have no real security.

> BERYL REID
> *So Much Love*

Theatre director; a person engaged by the management to conceal the fact that the players cannot act.

> attributed to JAMES AGATE

There are two kinds of directors in the theatre. Those who think they are God and those who are certain of it.

> RHETTA HUGHES

The King and Duke of York was at the play; but so great performance of a comical part was never, I believe, in the world before as Nell hath done this, both as mad girle, and the most and best of all, when she comes in like a young gallant and hath the motions and carriage of a spark, the most that ever I saw any man have. It makes me, I confess, admire her.

> SAMUEL PEPYS
> on seeing Nell Gwynne play Florimel in Dryden's
> *Mayden Queen, Diary*, 2 March 1667

This agreeable actress [Peg Woffington] in the part of Sir Harry, coming into the green room, said pleasantly: 'In my conscience half the men in the house take me for one of

their own sex.' Another actress replied: 'It may be so, but in conscience! the other half can convince them to the contrary.'

W.R. CHETWOOD
A General History of the Stage

When Mrs Siddons came into the room, there happened to be no chair ready for her, which he [Dr Johnson] observing said with a smile, 'Madam, you who so often occasion a want of seats to other people, will the more easily excuse the want of one yourself.'

JAMES BOSWELL
Life of Johnson

Mrs Siddons used to affect a great deal more than she felt; to lie on the stage, sometimes to counterfeint a faint, after a part of violent emotion. But I have supped with her afterwards and seen her eat a very hearty supper, after all this working of the passions.

HENRY MACKENZIE
Anecdotes and Egotisms

She can overpower, astonish, afflict, but she cannot win; her majestic presence and commanding features seem to disregard love, as a trifle to which they cannot descend.

LEIGH HUNT
Critical Essays on the Performances at the London Theatres

I never saw in my life such brilliant piercing eyes as Mr Garrick's are. In looking at him, when I have chanced to meet them, I have really not been able to bear their lustre.

FANNY BURNEY
Diary, 1771

Damn him, he could act a gridiron.
> KITTY CLIVE
> quoted by William Archer in his Introduction to the
> *Dramatic Essays of Leigh Hunt*

'Nothing is so fatiguing,' said Mrs Thrale, 'as the life of a wit; he [David Garrick] and Wilkes are the two oldest men of their ages I know, for they have both worn themselves out by being eternally on the rack to give entertainment to others.' 'David, madam,' said the Doctor [Johnson], 'looks much older than he is; for his face has had the double business of any other man's; it is never at rest; when he speaks one minute, he has quite a different countenance to what he assumes the next; I don't believe he ever has the same look for half an hour together in the whole course of his life; and such an eternal, restless, fatiguing play of the muscles must certainly wear out a man's face before its real time.'
> FANNY BURNEY
> *Diary*, 1778

On the stage he [Garrick] was natural, simple, affecting;
'Twas only that when he was off he was acting.
> OLIVER GOLDSMITH
> 'Retaliation'

I'll come no more behind your scenes, David [said Johnson]: for the silk stockings and white bosoms of your actresses excite my amorous propensities.
> JAMES BOSWELL
> *Life of Johnson*

When the witches accost him, his only expression of 'metaphysical influence' is to stand still with his eyes fixed and his mouth open ... In Charles Kean's Macbeth all tragedy has vanished; sympathy is impossible, because the mind of the criminal is hidden from us. He makes Macbeth ignoble with perhaps a tendency towards Methodism.

G.H. LEWES (of Charles, Edmund's brother)
Leader, 1853

There is in [Edmund] Kean, an infinite variety of talent, with a certain monotony of genius.

WILLIAM HAZLITT
Examiner, 10 December 1815

Just returned from seeing Kean in *Richard*. By jove, he is a soul! Life – nature – truth – without exaggeration or diminution. Kemble's Hamlet is perfect; – but Hamlet is not nature. Richard is a man; and Kean is Richard.

LORD BYRON
Journal, 19 February 1814

Kean is original; but he copies from himself. His rapid descents from the hyper-tragic to the infra-colloquial, though sometimes productive of great effect, are often unreasonable. To see him act, is like reading Shakespeare by flashes of lightning.

> SAMUEL TAYLOR COLERIDGE
> *Table Talk*

Novelty will always command notice in London, and Kean's acting, happily, was a novelty on the English stage. His croaking tones – his one-two-three-hop step to the right, and his equally brusque motions to the left – his retching at the back of the stage whenever he wanted to express passion – his dead stops in the middle of sentences – his hirre hurre, hop, hop, hop over all passages where sense was to be expressed, took amazingly.

> *Edinburgh Magazine*, Volume 16, 1824

We found him [Kean] as was usual after the performance of any of his principal parts, stretched on a sofa, retching violently, and throwing up blood. His face was half-washed – one side deadly pale, the other deep copper-colour.

> THOMAS COLLEY GRATTAN
> *Beaten Paths and Those Who Tread Them*

The Garrick school was all *rapidity* and *Passion*, while the Kemble school was so full of *paw* and *pause*, that, at first, the performers, thinking their new competitors had either lost their cues, or forgotten their parts, used frequently to. prompt them.

> ANN CRAWFORD, *c.* 1785

Lo, Kemble comes, the Euclid of the stage;
Who moves in given angles, squares a start,
And blows his Roman beak by rules of art;
Writhes with a grace to agony unknown,
And gallops half an octave in a groan.
ANON

Mr Kemble sacrifices too much to decorum. He is chiefly afraid of being contaminated by too close an identity with the character he represents. This is the greatest vice in an actor, who ought never to *bilk* his part.
WILLIAM HAZLITT
Mr Kemble's *Sir Giles Overreach* (*Examiner*, 5 May 1816)

On Sarah Bernhardt's initial visit to America, when the crowds went wild over her, one reporter exclaimed, 'Why, New York didn't give Dom Pedro of Brazil such an ovation!' Sarah serenely replied, 'Yes, but he was only an emperor!'
CORNELIA OTIS SKINNER
Madam Sarah

For the theatre one needs long arms; it is better to have them too long than too short. An *artiste* with short arms can never, never make a fine gesture.

SARAH BERNHARDT
Memories of My Life

There was among Sir Henry Irving's visitors at the Windsor [Hotel] a Glasgow town councillor ... who knew his own limitations as a speaker, and who ... induced Irving to give us some demonstrative lessons. They began with the recitation of many passages by Irving himself ... thereafter, he made each of us, seratim, recite a verse of some familiar poem ... On one occasion, it was Byron's 'There was a sound of revelry by night.' We were all stopped ... before the verse was finished ... 'I stopped you almost at once,' said our tutor to our friend the town councillor, 'because you said there was a *soundof*. What is a soundof? 'But I clearly said "soundof", pleaded Robert flushing. 'Quite,' agreed the actor, 'but what you meant to say was 'sound of' as the poet wrote it. If I hadn't stopped you, you would have said 'soundofrevlry' ... Yet the evening is still young ... There is no excuse ... 'Revelry' is a gallant word, entitled to all its vowels.'

NEIL MUNRO
The Brave Days

Somebody asked Gilbert if he had been to see Irving in *Faust*. 'I go to the pantomime,' said Gilbert, 'only at Christmas.'

LESLIE AYRE
The Gilbert and Sullivan Companion

He [Irving] does not merely cut plays, he disembowels them.

> BERNARD SHAW
> *Saturday Review*, 1896

It is the fate of actors to be judged by echoes which are altogether elusive – when they have passed out of immediate ken, and some fifty years hence some old fool will be saying – there never was an actor like Irving.

> SIR HENRY IRVING on himself
> *Letters*, 1891

He danced, he did not merely walk – he sang, he by no means merely spoke. He was essentially artificial, in distinction to being merely natural.

> EDWARD GORDON CRAIG
> *Henry Irving*

Lady Tree [Maud Holt] to her director: 'Mr A, it seems a little dark on the stage in this scene. Could you oblige us with a little more light? I think you may not have realised that my comedic effects in this play are almost wholly grimacial!'

> quoted by SIR JOHN GIELGUD
> *Backward Glances*

It is difficult to live up to one's poster ... When I pass my name in large letters I blush, but at the same time instinctively raise my hat.

> SIR HERBERT BEERBOHM TREE on himself
> quoted by Hesketh Pearson in *Beerbohm*

A charming fellow and so clever; he models himself on me.
 OSCAR WILDE

My eyes are nothing in particular. God gave me boot-buttons, but I invented the dreamy eyelid and that makes all the difference.
 MRS PATRICK CAMPBELL
 quoted by Sir John Gielgud

You will tell me no doubt that Mrs Patrick Campbell cannot act. Who said she could? Who wants her to act? – Who cares twopence whether she possesses that or any

Exasperated Old Gentleman (to Lady in front of him): 'Excuse me, Madam, but my seat has cost me ten shillings, and I want to *see*. Your hat–'
The Lady: 'My hat has cost me ten *guineas*, Sir, and I want it to *be seen!*'

other second-rate accomplishment? On the highest plane one does not act, one *is*. Go and see her move, stand, speak, look, kneel – go and breathe the magic atmosphere that is created by the grace of all those deeds; and then talk to me about acting, forsooth.

> BERNARD SHAW
> *Saturday Review*, 7 March 1896

Miss Flora Robson was one day taking tea with my wife and me. She was mourning over a procession of tortured spinsters leading to the crack of Doom. She foresaw that she would be expected by London managements to play them all ... I said, 'Would you like to play Mary Read?' And she said, 'Who is Mary Reed?' And I said, 'She was a pirate.' And Miss Robson said, 'Yes, I should like to play a pirate.' So I set to and wrote the play.

> JAMES BRIDIE
> *One Way of Living*

Boyish, brusque, inspired, exalted, mannerless, tactless and obviously, once she had served her turn, a nuisance to everybody.

> JAMES AGATE of Sybil Thorndike, in Bernard Shaw's
> *Saint Joan*

You're never too old to play Saint Joan; you're only too young.

> DAME SYBIL THORNDIKE
> quoted by Julie Harris in *Talks to Young Actors*

There is no sign that her acting would ever have progressed beyond the scope of the restless shoulders and the protuberant breasts; her technique was the gangster's technique – she toted a breast like a man totes a gun.

GRAHAM GREENE
Saratoga, 1937

It's very difficult not to breathe when you're playing dead, as all actors find out during their lives.

BERYL REID
So Much Love

Your motivation is your pay packet on Friday. Now get on with it.

NOËL COWARD to an actor (attributed)

My dear boy, forget about the motivation. Just say the lines and don't trip over the furniture.

NOËL COWARD to an actor in *Nude With a Violin* (attributed)

When you are a young man, Macbeth is a character part. When you're older, it's a straight part.

SIR LAURENCE OLIVIER
Theatre Arts, May 1958

A fan club is a group of people who tell an actor he's not alone in the way he feels about himself.

JACK CARSON

The better the actor the more stupid he is.

TRUMAN CAPOTE

Being another character is more interesting than being yourself.

SIR JOHN GIELGUD

I wasn't cut out to be an actor. I haven't the energy for acting – it's too exhausting.

LESLIE HOWARD

The physical labor actors have to do wouldn't tax an embryo.

SPENCER TRACY

I can't for the life of me see what nudity has to do with good acting. But perhaps if I were younger, I would feel differently.

JULIE HARRIS
Talks to Young Actors

I'm as pure as driven slush.
> TALLULAH BROCKMAN BANKHEAD
> *Observer*, 24 February 1957

Watching Tallulah Bankhead on the stage is like watching somebody skating on very thin ice – and the English want to be there when she falls through.
> MRS PATRICK CAMPBELL

Claudette Cobert: 'I knew these lines backwards last night, Noël'
Noël Coward: 'That, my dear, is the way you're saying them this morning.'

After curtain call
Her
 face
 falls
– Then someone says Darling
You were marvellous
– and she picks it up again
> MICHAEL HOROVITZ

He delivers every line with a monotonous tenor bark as if addressing an audience of dead Eskimos.

> MICHAEL BILLINGTON of Peter O'Toole in *Macbeth*
> *Guardian*

His performance suggests that he is taking some kind of personal revenge on the play.

> ROBERT CUSHMAN of the same production
> *Observer*

My only regret in the theatre is that I could never sit out front and watch me.

> EDDIE CANTOR
> *The Way I See It*

I acted so tragic the house rose like magic,
The audience yelled, 'You're sublime.'
They made me a present of Mornington Crescent,
They threw it a brick at a time.

> W.F. HARGREAVES (1846-1919)
> 'The Night I appeared as Macbeth' (song)

The whole of art is an appeal to a reality which is not without us but in our minds.

> DESMOND MACCARTHY
> *Theatre 1930*, Modern Drama

How often in the past has the theatre been said to be in its last throes, yet it obstinately continues to survive.

> SIR JOHN GIELGUD
> *Backward Glances*

Opera is a bizarre mixture of poetry and music where the writer and the composer, equally embarrassed by each other, go to a lot of trouble to create an execrable work.

> SIEUR de SAINT-EVREMOND
> in a letter to the Duke of Buckingham, 1677

A fatuity laden with music, with dances, with machinery and scenery, is a magnificent fatuity, but a fatuity none the less.

> SIEUR de SAINT-EVREMOND
> in a letter, 1678

Nothing is capable of being set to music that is not nonsense.

> JOSEPH ADDISON
> *Spectator*, 1711

One goes to see a tragedy to be moved, to the opera one goes either for want of any other interest or to facilitate digestion.

> VOLTAIRE

No good opera will ever be written. Music does not know how to narrate.

> NICOLAS BOILEAU-DESPRÉAUX
> quoted by Beaumarchais in his Preface to *Tarave*, 1790

No good opera plot can be sensible, for people do not sing when they are feeling sensible.

> W.H. AUDEN

Musical Authority: 'Yes, Schubert wrote it, but not for the trapeze.' (1935 *Punch* cartoon)

I don't really believe in it [opera]. You know, how can people sing away their troubles? How can they all make love to each other singing?

JOSE QUINTERO

I have never encountered anything more false and foolish than the effort to get truth into opera. In opera everything is based upon the not-true.

PYOTR ILYICH TCHAIKOVSKY
Diaries, 1888

Opera is where a guy gets stabbed in the back, and instead of dying, sings.

attributed to RICHARD BENCHLEY

The opera is to music what a bawdy house is to a cathedral.

H.L. MENCKEN
in a letter to Isaac Goldberg

The most rococo and degraded in all forms of art.

WILLIAM MORRIS

A writer of operatic librettos, if he wishes to be modern, must not have read the Greek and Latin classic authors ... For the finale of his opera ... he should conclude with the customary chorus in praise of the sun, the moon, or the impresario.

BENEDETTO MARCELLO
Il Teatro alla mode, 1720

In opera, the text must be the obedient daughter of the music.

WOLFGANG AMADEUS MOZART

What more is necessary to inform us of all which the following gentleman has for sale, than the bell which he tinkles at the end of his cry?

Grove	Heart	Kiss
Night	Prove	Blest
Rove	Impart	Bliss
Delight	Love	Rest

Was there ever peroration more eloquent? ... The Italian *rimatore* are equally comprehensive ... For example –

Ben mio	*Fuggito*
Oh Dio	*Rapito*
Per te	*Da Me*

LEIGH HUNT on Opera Poets
'Rhyme and Reason', Essays

Matron in Stalls (reads from programme): ' "Overture to L'Onfong Prod-eeg". The prodigious child, eh?'
Accomplished daughter (shocked): 'Mamma, dear! No – "L'Enfant Prodigue" – it means the Infant Prodigy!'

The three principal personages of the drama ought to sing five arias each; two in the first act, two in the second, and one in the third. The second actress and the second soprano can only have three, and the inferior characters must be satisfied with a single aria each. The author of the words ... must, above all things, avoid giving impassioned airs, bravura airs, or rondeaus, to inferior characters; these poor devils must be satisfied with what they can get, and every opportunity of distinguishing themselves is denied them.

> CARLO GOLDONI
> *Mémoirs*, 1787

Steve Race: Denis, translate into English *La Donna e Mobile*.
Denis Norden: The bird's got a motorbike.

> from the BBC quiz programme *My Music*, quoted by
> IAN WALLACE
> *Nothing Quite Like It*

Opera in English, is, in the main, just about as sensible as baseball in Italian.

> H.L. MENCKEN
> *Prejudices*

The *Beggar's Opera* was offered to Cibber, then manager of Drury Lane, and rejected by him. It was then offered to Rich, the rival potentate of Covent Garden, who had the good sense and good fortune to accept it. Its profits were so very great, both to the author and the manager, that it was

said that the *Beggar's Opera* had made Rich gay and Gay rich.

GEORGE HOGARTH

Opera comes to me before anything else.

WOLFGANG AMADEUS MOZART
in a letter to his father, 17 August 1782

Then on to *Figaro* at the Old Vic. It's perfectly lovely, breaking from one beauty into another, and so romantic as well as witty – the perfection of music and the vindication of opera.

VIRGINIA WOOLF
Diary, 1917

The opera bored me.

COUNT KARL VON ZINZENDORF
Diaries, 1786

Don Giovanni is the opera of operas.

LEOS JANACEK

Take a farmer from Essoyes to hear the masterpiece of all masterpieces, Mozart's *Don Giovanni*, he'd be bored stiff. He'd much prefer a café concert.

PIERRE-AUGUSTE RENOIR
Renoir, My Father

Jones and I went last Friday to *Don Giovanni* ... It bored us both ... We admit the beauty of many of the beginnings of the airs, but this beauty is not maintained, in every case the

air tails off into something that is much too near being tiresome. The plot, of course, is stupid to a degree ...
SAMUEL BUTLER
At the Opera, *Notebooks*

Music in the theatre knows no other rule, and no other judge than the heart ... What the composer must express is, not an overloaded orchestra, but heart, feeling and passion. Only as he writes in a great style, only then will his name be given to posterity. Grétry, Monsigny, and Philidor prove this. Mozart in his *Don Giovanni* intended to write something uncommonly, inimitably great. There is no doubt: the uncommon is here, but not the inimitably great! Whim, caprice, ambition, but not heart created *Don Giovanni*.
Chronik von Berlin, 1790

After Don Juan has wounded her pride and killed her father, Donna Anna's wrath breaks out like a rushing torrent ... in which every note in the orchestra seems to speak of her wrath, her pride and actually to quiver with horror – I could cry out and weep under the overwhelming stress of the emotional impression. And her lament over her father's corpse in which she vows vengeance, her arioso in the great sextet in the churchyard – these are inimitable, colossal operatic scenes ... It is thanks to Mozart that I have devoted my life to music.
PYOTR ILYICH TCHAIKOVSKY
in a letter to Nadejda von Meck, 1878

Cosi Fan Tutte is a long summer day spent in a cloudless land by a southern sea, and its motto might be that of Hazlitt's sundial: 'I count only the hours that are serene.'
> SIR THOMAS BEECHAM
> *A Mingled Chime*

A miserable thing which lowers all women, cannot possibly please female spectators, and will therefore not make its fortune.
> FRIEDRICH LUDWIG SCHROIDER
> actor, in his diary, 1790, after seeing *Cosi Fan Tutte*

The Magic Flute remains Mozart's greatest work, for only in this did he show himself to be a German master. *Don Giovanni* is still cut to the Italian pattern, entirely so, and besides, Art, which is sacred, should never be debased in the service of so scandalous a subject.
> LUDWIG van BEETHOVEN

The Amazing Whistle.
> Swedish translation of *The Magic Flute*
> quoted by STEVE RACE, *My Music*

The strangest among the musical products of the last month was certainly Beethoven's long-expected opera *Fidelio* ... It was performed for the first time on November 20, but was received very coldly ... Whoever has followed with interest and serious scrutiny the march of Beethoven's otherwise uncontested talent, must expect something different from what we were given. Beethoven has often sacrificed beauty to novelty and strangeness. One ought, therefore, to

expect, first of all, peculiarity, novelty, and some original creative splendour from his first theatrical creation. The whole, regarded calmly and without bias, is neither conspicuous by invention nor by performance. The choruses are without effect, and one of them which expresses the delight of the prisoners in enjoying fresh air, is a manifest failure.

Allgemeine Musikalische Zeitung, January 1806

In a sense there was nothing left but anti-climax
when at last the surging heroics had to stop
with Freedom, noble and serene in triumph,
applauded past the final curtain-drop.

But the Minister had to take his anonymity
back to his office; see that there was got
in train the customary procedures
for having political prisoners discreetly shot:

Fidelio strip off her male disguises,
take on her Florestan's love and come to bear
and rear his children, the common lot of women
whatever clothes or circumstance they wear.

The prisoners found they'd lost the art of singing
rapt choruses to the age-old ultimate foe
all peasants have to reckon with, deaf poverty,
leaving them life, but little else to show.

What of these weedy soldiers who'd obeyed
Pizzaro's orders, whose defeat they'd cheered?
They betted on how long they'd lounge in barracks
before the same old sequence reappeared.
 MAURICE LINDSAY
 'Overture Leonora Number Next'
 Collected Poems 1940-1990

By 1825, the 'Caledonian' [Theatre] was up for sale, and the most colourful of ... Glasgow's actor-managers, John Henry Alexander, ... tried to buy it, only to find that Seymour, the manager of the Queen Street Theatre, had forestalled him. So Alexander bought the cellar underneath the 'Caledonian', and on the night when Seymour opened upstairs with *Macbeth*, downstairs Alexander opened in the basement (which he had advertised as 'The Dominion of Fancy'), with a piece called *The Battle of Inch*. Walter Baynham, in ... the *Glasgow Stage*, wrote of that opening night: '*Macbeth* was acted ... throughout to the tuneful accompaniment of the shouts of the soldiery ... with the fumes of blue fire every now and then rising through the chinks of the planks from the stage below to the stage above' ... [An] instruction by the magistrates that 'neither party was to annoy the other' led to Seymour's upstairs audience lifting floorboards and pouring water on Alexander's audience beneath ... There was a final flurry when the two theatres offered simultaneous productions of Weber's *Freischutz*. On Alexander's first night, Seymour's supporters lifted the stage planks during the incantation scene, grabbed the dragon by the tail, and prevented him extinguishing his fumes, to the great consternation of that inflamed monster.

> MAURICE LINDSAY
> *Glasgow*, 1972

Carve in your head in letters of brass: An Opera must draw tears, cause horror, bring death, by means of song.

> VINCENZO BELLINI
> in a letter to his librettist

The music is horrible. In the great days of Greece this subversion of all melody, this rape of beauty, would have been punished by the state. Such music is a criminal offence. This work can only please fools, or idiots, or scholars, or highway robbers, or murderers.

FRANZ GRILLPARZER on Weber's *Euryanthe*

The French Opera, which I have heard tonight, disgusted me as much as ever; and the more for being followed by the *Devin du Village* [by Jean Jacques Rousseau], which shows that they can sing without cracking the drum of one's ear. The scenes and dances are delightful ...

HORACE WALPOLE
in a letter to Lady Hervey, 14 September 1765

Carmen must stand on its own merits – and these are very slender. It is little more than a collocation of couplets and chansons ... and, musically, is really not much above the works of Offenbach. As a work of art it is nought.

New York Times, 24 October 1878

Without being a work of overpowering genius, *Carmen* is an opera that may be heard with pleasure and profit ... more than can be asserted of many productions of the modern school which have been accorded the honour of representation abroad and in London.

Musical Times, July 1898

The Prelude to *Tristan and Isolde* reminds me of the old Italian painting of a martyr whose intestines are slowly unwound from his body on a roll.

EDUARD HANSLICK

Of all the bête, clumsy, blundering, boggling, baboon-blooded stuff I ever saw on a human stage, that thing last night beat – as far as the story and acting went: and of all the affected, sapless, soulless, beginningless, endless, topless, bottomless, topsiturviest, tongs and boniest doggerel of sounds I ever endured the deadliest of, that eternity of nothing was the deadliest – as far as the sound went, I never was relieved ... by the stopping of any sound – not excepting railway whistles – as I was by the cessation of the cobbler's bellowing; even the serenader's caricature twangle was a rest after it. As for the great *Lied*, I never made out where it began, or where it ended – except by the fellow's coming off the horse block.

> JOHN RUSKIN on *Die Meistersinger*
> in a letter to Mrs Burne-Jones, 30 June 1882

Die Walküre is endured by the average man because it contains four scenes for which he would sit out a Scotch sermon, or even a House of Commons debate. These are the love duet in the first act, Brynhild's announcement to Siegmund of his approaching death in the second, the ride of the Valkyries and the fire-charm in the third. For them the ordinary play-goer endures hours of Wotan, with Christopher Sly's prayer in his heart – 'Would twere over!'

> BERNARD SHAW
> *Bassetto at Bayreuth, How to Become a Music Critic*

Rigoletto is the weakest work of Verdi. It lacks melody. This has hardly any chance to be kept in the repertoire.

> *Gazette Musicale de Paris*, 22 May 1853

Herr Wagner, as seen by *Punch*

The favourite opera of the season has been *La Traviata*. The highest society in England has thronged the opera house night after night to see a very young and innocent-looking lady impersonate the heroine of an infamous French novel, who varies her prostitution by a frantic passion ... Verdi's music, which generally descends below his subjects, can in this case claim the ambiguous merit of being quite worthy of the subject.

 London Spectator, 1856

Verdi ... has bursts of marvellous passion. His passion is brutal, it is true, but it is better to be impassioned in this way than not at all. His music is at times exasperating but is never boring.

 GEORGES BIZET
 in a letter to his mother, 1859

It's organ grinder stuff.

 CHARLES GOUNOD of *Ernani*

When Verdi sees a strong dramatic situation, he rushes straight into the thick of it like a mad bull.

 Boston Evening Telegraph, 20 March 1882

In *La Bohème*, silly and inconsequential incidents and dialogues ... are daubed over with splotches of instrumental colour without reason and without effect ... The expression is superficial and depends upon strident phrases pounded out by hitting each note a blow on the head as it escapes from the mouths of singers or the accompanying instruments.

 H.F. KREHBIEL, writing in 1900

You can be sure there will be undertaker's work at the end of most operas.

S. JOHN PESKETT
This Music Business

There was a time when I heard eleven operas in a fortnight ... which left me bankrupt and half idiotic for a month.

J.B. PRIESTLEY
All About Ourselves, 1923

Music even less charming than I expected. Plot all about drinking, whoring and money. Names of tarts on the lips of characters all the time ...

ARNOLD BENNETT on *The Merry Widow*

Operetta is the daughter of *opéra comique* – a daughter who went to the bad. Not that daughters that go to the bad are always lacking in charm.

CAMILLE SAINT-SAENS

At one of the rehearsals of *Les Paladins* Rameau repeatedly told one of the actresses to take a certain air much faster. 'But if I sing so fast,' said the artiste, 'the public will not be able to hear the words.' 'That doesn't matter,' replied the composer. 'I only want them to hear my music.'

R.B. DOUGLAS
Sophie Arnould, 1898

Handel has set up an Oratorio against the Operas, and succeeds. He has hired all the goddesses from farces and the singers of 'Roast Beef' from between the acts at both theatres, with a man with one note in his voice, and a girl

without ever a one: and so they sing, and make brave hallelujahs; and the good company encore the recitative if it happens to have any cadence like they call a tune.

> HORACE WALPOLE
> in a letter to Sir Horace Mann, 24 February 1743

'You have taken too much trouble over your opera,' Handel told Gluck, who wanted an opinion of *La Caduta dei giganti*. 'Here in England, that is mere waste of time. What the English like is something they can beat time to, something that hits them straight on the drum of the ear.

> A.W. SCHMIDT
> *C.W. Ritter von Gluck*

I sought to reduce the music to its true function, that of aiding the poetry, in order to reinforce the expression of feeling without interrupting the action and chilling it by superfluous ornament. I consider that the music ought to add to the poetry what vivacity of colouring and a happy concord of light and shade add, by animating the figures without altering their contours, to a correct and well-composed design.

> GLUCK
> Preface to *Orfeo*, 1762

Without interfering in the famous fight [between Gluckists and Piccinists], I must confess that Gluck's work seemed to leave an extraordinary impression ... I do not know if this is singing, but it is perhaps something better than that. Hearing his *Iphigenie* I forget that I am in an opera house and I think I am hearing a great tragedy.

> BARON FRIEDRICH MELCHIOR von GRIMM, 1779

I have an unspeakable desire to compose opera ... In Italy, one can acquire more honour and credit with an opera than with a hundred concerts in Germany, and I am the happier because I can compose, which, after all, is my one joy and passion ... I am beside myself as soon as I hear anybody talk about an opera, sit in a theatre or hear singing.

WOLFGANG AMADEUS MOZART
in a letter to his father, 11 October 1777

A great deal of noise ... is always appropriate at the end of an act. The more noise the better, and the shorter the better, so that the audience has no time to cool down with their applause.

WOLFGANG AMADEUS MOZART
in a letter, 1781

Lady (to big drum): 'Pray, my good man, don't make that horrid noise – I can't hear myself speak!'

At the final rehearsal [in Prague, of *Don Giovanni*], Mozart was not at all satisfied with the efforts of a young and very pretty girl, the possessor of a voice of greater purity than power, to whom the part of Zerlina had been allotted. Zerlina, frightened at Don Giovanni's too pronounced love-making, cried for assistance behind the scenes, but in spite of continued repetitions, Mozart was unable to infuse sufficient force into the poor girl's screams, until at last, losing all patience, he clambered from the conductor's desk on to the boards. At that period neither gas nor electric light lent facility to stage mechanism. A few tallow candles dimly glimmered among the desks of the musicians, but over the stage and the rest of the house utter darkness reigned. Mozart's sudden appearance on the stage was not noticed ... by poor Zerlina, who at the moment she ought to have uttered the cry received from the composer a sharp pinch on the arm, emitting in consequence a shriek, which caused him to exclaim: 'Admirable! Mind you scream like that tonight.'

> quoted from WENZEL SWOBODA in Wilhelm Kuhe's *Memories of a Musician*

Mozart is happiness before it has gotten defined.
> ARTHUR MILLER

As a director, my definition of paradise would be to be perpetually rehearsing Mozart operas.
> SIR PETER HALL

Rehearsals [for the revised *Fidelio*] started in mid-April although the score was far from ready. The performance was announced for 23 May. On the 22 the dress rehearsal took place, but the promised new overture was still in its

creator's pen. The orchestra was summoned to rehearse on the morning of the opening. Beethoven did not come. After waiting for some time, I went to get him. I found him in bed, fast asleep. Beside the bed were a cup of wine and some biscuits. The sheets of the overture were scattered over the bed and the floor. A burned-out candle showed that he had worked far into the night. Obviously, the overture could not be completed, and for this performance the overture to *Prometheus* was used ... You already know the rest ... Beethoven conducted, but his enthusiasm often made him miss the beat, and it was the Kapellmeister Umlauf who stood behind his back and succeeded by look and gesture in keeping everyone together. The applause was loud and grew louder with every performance.

ANTON FELIX SCHINDLER
Beethoven As I Knew Him, 1840

I remember meeting Gounod once in the Rue de la Chaussée d'Antin. It was just after ... *Faust* had been given at the Théâtre Lyrique, and to my amazement, had met with a rather doubtful success. The Soldiers' Chorus, the waltz especially, was very much applauded, praised, and bought, but what is really grand in the opera people seemed very slow to appreciate; and so I said to him, 'Is it not curious that people should take so to the Soldiers' Chorus, which, you must really agree with me, is not exactly the most distinguished piece in the opera?' 'Ah, my dear E,' he said, 'don't you see, operas are not born like men, head foremost; operas are born feet foremost.'

LOUIS ENGEL
Mozart

A base soul who poured a sort of bath-water melody down the back of every woman he met. Margaret or Madeline, it was all the same.

> GEORGE MOORE on Gounod
> *Memoirs of My Dead Life*

Every number in *Figaro* is for me a marvel; I simply cannot understand how anyone could create anything so perfect: such a thing has never been done, not even by Beethoven.

> JOHANNES BRAHMS

'Do you know what Wagner's music sounds like?' Rossini asked me one day. Opening the piano and seating himself heavily on the keys, he exclaimed, 'There, that's the music of the future.'

> LOUISE HÉRITTE-VIARDOT
> *Memories and Adventures*, 1913

Standing one night at the back of the dress circle, Sullivan commenced in a contemplative fashion to hum the melody of a song that was being rendered on the stage. 'Look here,' declared a sensitive old gentleman, turning around sharply … 'I've paid my money to hear Sullivan's music, not yours.'

> SIR HENRY A. LYTTON
> *The Secrets of a Savoyard*

Siegfried was abominable. Not a trace of coherent melodies. It would kill a cat and would turn rocks into scrambled eggs from fear of these hideous discords.

> RICHARD STRAUSS
> in a letter to Ludwig Thuille, 1879
> (But Strauss, writing to Roland Tenschert in 1950,

hoped that his performances of *Parsifal* at Bayreuth
had earned him 'perpetual absolution from these
idiotic youthful transgressions'.)

When Wagner wrote trombone parts for a chorus in one of
Spontini's operas, the composer ... sent for the parts when
he was producing the opera in Berlin, and was kind enough
to say it was a great pity Wagner could never become a
great composer as he Spontini had exhausted the
possibilities of music.
BERNARD SHAW
'Handel's Messiah', *How to Become a Music Critic*

On 8 December 1881, fire broke out at the Ring Theatre in
Vienna, during a performance of *The Tales of Hoffman*: 384
members of the audience burned to death. Richard Wagner
commented: 'When miners in a coal pit are buried alive, I
am deeply moved and horrified, filled with disgust for a
society which obtains its heating fuel by such means. But it
leaves me cold and scarcely moved when members of an
audience perish while listening to an Offenbach operetta,
which contains not one iota of worth.'
K.F. GLASENAPP
Das Leben Richard Wagner, 1894

The Mozart of the Champs-Elysées.
GIOACCHINO ROSSINI
of Offenbach

Traviata a fiasco last night [in Venice]. Is it my fault or that of the singers? ... Time will decide.

> GIUSEPPE VERDI
> in a letter to Emanuele Muzio, 7 March 1853

When *La Traviata* was a failure at Venice, Varesi, the baritone, and other interpreters of the work, thinking to console Verdi, paid him their condolences; but he only exclaimed: 'Make them to yourself and your companions, who have not grasped my music.'

> FREDERICK CROWEST
> *Verdi, Man and Musician*, 1897

Like Verdi, when, at his worst opera's end
(The thing they gave at Florence, what's its name?)
While the mad houseful's plaudits near outbang
His orchestra of salt-box, tongs, and bones,
He looks through all the roaring and the wreaths
Where sits Rossini patient in his stall.

> ROBERT BROWNING
> 'Bishop Blougram's Apology'

The evening of 17 February 1904 had a black ending, and *Madame Butterfly* was hissed ... Puccini ... sat in the wings watching the uproar increasing ... 'Splendid! – Louder still, you beasts! – Shriek, yell, jeer at me! – You shall see! – Ruin it all for me! – It is I who am right! – It is the finest opera I have ever written!'

 RICHARD SPECHT
 Giacomo Puccini

When Britten visited Russia, he and Shostakovitch became friends. 'What do you think of Puccini?' Shostakovitch asked once. 'His operas are dreadful,' said Britten. 'No, Ben, you're wrong,' said Shostakovitch. 'He wrote marvellous operas but dreadful music.'

 LORD HAREWOOD
 The Tongs and the Bones

An English singer, named Gordon, once found fault with Handel's method of accompanying. High words ensued; and Gordon finished by saying, that if Handel persisted in accompanying him in that manner, he would jump on his harpsichord and smash it to pieces. 'Oh,' replied Handel, 'let me know when you will do that, and I will advertise it: for I am sure more people will come to see you jump than to hear you sing.'

 WILLIAM S. ROCKSTRO
 The Life of George Frederick Handel, 1883

Madam, I know you are a veritable devil, but I would have you know that I am Beelzebub, the head devil.

 GEORGE FREDERICK HANDEL, in 1723, to Francesca Cuzzoni

Damn it, she's got a belly full of nightingales!
> voice from the audience, of Cuzzoni as Cleopatra, at
> the London première of Handel's *Julius Caesar*

> Little siren of the stage,
> Charmer of an idle age,
> Empty warbler, breathing lyre,
> Wanton gale of fond desire,
> Bane of every manly art,
> Sweet enfeebler of the heart.
> O, too pleasing is thy strain,
> Hence to southern climes again;
> Tuneful mischief, vocal spell,
> To this island bid farewell:
> Leave us as we ought to be,
> Leave the *Britons* rough and free.
>> AMBROSE PHILIPS
>> 'To Signora Francesca Cuzzoni', 25 May 1724

At Ranelagh, I heard the famous Tenducci, a thing from Italy; it looks for all the world like a man, though they say it is not. The voice, to be sure, is neither man's nor woman's; but it is more melodious than either, and it warbled so divinely, that, while I listened, I really thought myself in paradise.
> TOBIAS SMOLLETT
> Humphry Clinker, 1771

For my part, I am convinced that people applaud a prima donna as they do the feats of the strong man at the fair. The sensations are painfully disagreeable, hard to endure, but one is so glad when it is all over that one cannot help rejoicing.

> JEAN-JACQUES ROUSSEAU
> *La Nouvelle Héloise*, 1761

The Prima-donna, though a little old,
And haggard with a dissipated life,
And subject, when the house is thin, by cold,
Has some good notes ...

> LORD BYRON
> *Don Juan*

The tenor's voice is spoilt by affectation
And for the bass, the beast can only bellow:
In fact, he had no singing education,
An ignorant, noteless, timeless, tuneless fellow.

> LORD BYRON
> *Don Juan*

Once when auditioning a baritone for *Carmen*, Sir Thomas remarked, 'He's made a mistake – he thinks he's the bull instead of the toreador.'

> *Beecham Stories*, ed. Atkins and Newman

Tenors are noble, pure and heroic and get the soprano, if she has not tragically expired before the final curtain. But baritones are born villains in opera. Always the heavy and never the hero – that's me.

> LEONARD WARREN, writing in 1957

Negotiations were in progress at Covent Garden for the engagement of a distinguished and decidedly voluptuous soprano to sing there. She demanded an enormous fee. 'But,' protested the Garden manager of the day, 'all we want her to do is sing!'

The London hangman went one night to the pit of Her Majesty's Theatre to hear Jenny Lind, and on seeing the Swedish nightingale, exclaimed, breathless with admiration and excitement, 'What a throat to scrag!'

The Swedish Nightingale
Jenny Lind

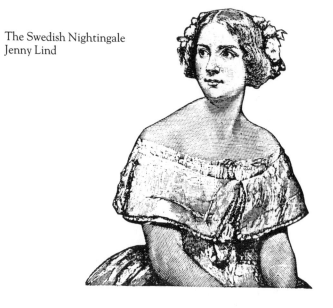

I would give the whole of Bach's Brandenburg Concertos for Massenet's *Manon* and would think I had greatly profited by the exchange.

SIR THOMAS BEECHAM
Beecham Stories, ed. Atkins and Newman

Who sent you to me – God?

GIACOMO PUCCINI on hearing Caruso at an audition

Caruso was dragging out his arias. '*Chi son? Chi son?*' (Who am I?) he sang slowly. '*Sei vu imbecile!*' (You're a fool) retorted Puccini, to general delight.

HENRY RUSSELL
The Passing Show

Regard your voice as capital in the bank ... Sing on your interest and your voice will last.

LAURITZ MELCHIOR
News Summaries, 1 April 1952

The British laryngologist Sir Felix Semon asked Adelina Patti why she had never sung any of Wagner's roles. She looked at him with her beautiful eyes and simply asked, 'Have I ever done you any harm?'

SIR FELIX SEMON
Autobiography, 1926

About the middle of September the theatre opened, and we went to hear Verdi's *Ernani*. Liszt looked splendid as he conducted the opera. The grand outline of his face and floating hair were thrown into dark relief by the stage lamps. We were so fortunate as to hear all three of Wagner's most celebrated operas while we were at Weimar.

The declamation [in *Lohengrin*] appeared to me monotonous, and situations, in themselves trivial or disagreeable, were dwelt on fatiguingly. Without feeling competent to pass a judgement on this opera as music, one may venture to say it fails in one grand requisite of art, based on an unchangeable element in human nature – the need for contrast.

GEORGE ELIOT
Journal, 1854

Liszt conducting one of his oratorios

Richard Strauss laughed incredulously when Beecham said he proposed to conduct the first London performance of *Elektra* without a score. 'I'll bet you one hundred pounds I will learn it in a fortnight,' said Beecham. He did so, but Strauss returned to Germany without paying the bet. When the time came for payment of the composer's royalties, there was a deduction from the total: 'To one bet, £100.'

> LESLIE AYRES
> *The Wit of Music*

The censorship had discovered the presence of a bed in a remote part of the stage in the third act [of *Der Rosenkavalier*] and were worried about some equivocal references to it in the text. Those who know the work will remember how Octavian, disguised as a girl, inquires the purpose of this object from the Baron Ochs, who replies, '*Das wird sie schon seh'n*'. There was nothing more offensive in this than in a hundred other things heard nightly on the lighter musical stage, but evidently the guardian angels of our national morality were haunted by the idea that what was harmless and innocent at Daly's or the Gaiety Theatre would be dangerous and reprehensible at Covent Garden. I was given the option of two courses. Either the bed could be exhibited without any reference being made to it, or it could be hidden away from sight and we could sing about it as much as we liked. As it was easier to move the furniture around than to tamper with the score of the work, I accepted the second alternative, and I have always regarded this as a nearly perfect example of our British love of compromise.

> SIR THOMAS BEECHAM
> *A Mingled Chime*

One day I'm a prostitute and the next day I'm a nun. Where else could you get instant conversion like that?
> LOIS BOOTSIN on her work as a supernumary at the Metropolitan Opera
> *New York Times*, 19 November 1984

Sing 'em muck – it's all they can understand.
> DAME NELLIE MELBA to Clara Butt, who was about to visit Australia

A mutual friend asked Melba if it were true that she had really given Clara Butt this dangerous advice. 'Of course not,' retorted Melba. 'In Clara's case it wasn't necessary.'
> IVOR NEWTON
> *At the Piano*

I will not enter into a public feud with Madame Callas, since I am well aware that she has considerably greater competence and experience at that kind of thing than I have.
> RUDOLPH BING
> quoted by Amory and Blackwell, *Celebrity Register*, 1963

W.S. Gilbert once directed an actor to sit down in a 'pensive fashion'. The man took his seat slowly but heavily, knocking over as he descended a large part of the scenery. 'I said *pensively*,' flashed Gilbert, 'not *ex-pensively*.'
> SIR HENRY A. LYTTON
> *The Secrets of a Savoyard*

You need three things in the theatre – the play, the actors and the audience, and each must give something.
 KENNETH HAIGH

Audiences will forgive you practically anything, except boring them.
 show business axiom

 Some come to take their ease
 And sleep an act or two.
 WILLIAM SHAKESPEARE
 Henry VIII

The play was a great success, but the audience was a disaster.
 attributed to OSCAR WILDE

 The drama's laws the drama's patrons give,
 For we, who live to please, must please to live.
 SAMUEL JOHNSON

Mr Lovelli: Do you come to the play without knowing what it is?

Answer: O, yes, Sir, yes, very frequently: I have no time to read play-bills; one merely comes to meet one's friends, and show that one's alive.
 FANNY BURNEY
 Evelina

A large proportion of most British audiences [at the theatre] have no clearer impression of the meaning of what is going on in the illuminated area behind the frame than a dog has of Velasquez.
> JAMES BRIDIE
> *One Way of Living*

Long experience has taught me that in England, nobody goes to the theatre unless he or she has bronchitis.
> JAMES AGATE

The audience strummed their catarrhs.
> ALEXANDER WOOLLCOTT
> *While Rome Burns*

In London, theatregoers expect to laugh; in Paris, they wait grimly for proof that they should.
> ROBERT DHÉRY
> *Look*, 4 March 1958

There is no question but our grand-children will be very curious to know the reason why their forefathers used to sit together like an audience of foreigners in their own country, and to hear whole plays acted together before them in a tongue which they do not understand.
> JOSEPH ADDISON
> *Spectator*, 1710

English is a terrible language for vocalising. Try singing Love or Death. But, ah! – *Liebe, Amore, Tod!*
> quoted by LESLIE AYRE
> *The Wit of Music*

The Public doesn't *want* to be asked to work; it doesn't seek to understand: it merely wants to *feel* and *feel* immediately.

 CHARLES GOUNOD
 in a letter to Mme Charles Rhone, 1886

Over his cup of coffee, he bethought him that he would go to the opera. In the *Times*, therefore – he had a distrust of other papers – he read the announcement for the evening. It was *Fidelio*. Mercifully, not one of those new-fangled German pantomimes by that fellow Wagner ... Folding his opera hat, he sat down, drew out his lavender gloves for a long look round the house. Dropping them at last on his folded hat, he fixed eyes on the curtain. More poignantly than ever he felt that it was all over and done with him. Where were all the women, the pretty women, the house used to be so full of? Where was that old feeling in the heart as he waited for one of those great singers? Where that sensation of the intoxication of life and of his own power to enjoy it all? The greatest opera-goer of his day! There was no opera now! That fellow Wagner had ruined everything; no melody left, nor any voices to sing it. Ah! the wonderful singers! He sat watching the old scene acted, a numb feeling at his heart.

 JOHN GALSWORTHY
 The Man of Property

This present opera was *Parsifal*. Madame Wagner does not permit its representation anywhere but in Bayreuth. The first act of the three occupied two hours and I enjoyed that in spite of the singing.

 MARK TWAIN
 'At the Shrine of St Wagner', *Essays*

I have seen all sorts of audiences – at theatres, operas, concerts, lectures, sermons, funerals – but none which was twin to the Wagner audiences at Bayreuth for fixed and reverential attention. Absolute attention and petrified attention to the end of the act of the attitude assumed at the beginning of it. You detect no movement in the solid mass of heads and shoulders. You seem to sit with the dead in the gloom of a tomb. You know that they are being stirred to their profoundest depths ... yet you hear not one utterance till the curtain swings together and the closing strains have faded out and died; then the dead rise with one impulse and shake the building with their applause. Every seat is full in the first act; there is not a vacant one in the last. If a man would be conspicuous, let him come here and retire from the house in the midst of an act. It would make him celebrated.

> MARK TWAIN
> *Collected Works*

Sleep is an excellent way of listening to an opera.

> JAMES STEPHENS

Bear in mind that you are not making music for your own pleasure, but for the pleasure of your audience. You must not perspire while conducting; only the public must get warm. Direct *Salome* and *Elektra* as if they had been written by Mendelssohn: Elfin music.

> RICHARD STRAUSS
> *Ten Golden Rules Inscribed in the Album of a Young Conductor*

Successes are made by the public, not by the critics.
> HUGO von HOFMANNSTHAL
> to Richard Strauss, 23 July 1911

Those who say they give the public what it wants begin by underestimating public taste, and end by debauching it.
> ANON
> quoted in the *Pilkington Report*, 1960

Judge not the play before the play is done.
> SIR JOHN DAVIS
> *Respice Finem*

A critic is a man who knows the way but can't drive the car.
> KENNETH TYNAN

Critics are like eunuchs in a harem. They're in there every night, they see how it should be done every night, but they can't do it themselves.
> BRENDAN BEHAN
> quoted by Gyles Brandreth in *Great Theatrical Disasters*, 1983

A drama critic is a man who leaves no turn unstoned.
> GEORGE BERNARD SHAW
> *New York Times*, 1950

There's no possibility of being witty without a little ill-nature.
> RICHARD BRINSLEY SHERIDAN

A dramatic critic is a person who surprises the playwright by informing him what he meant.
> WILSON MIZNER

Critics search for ages for the wrong word, which, to give them credit, they eventually find.
> PETER USTINOV
> *BBC Radio*, February 1952

The critic leaves at curtain fall
To find, in starting to review it,
He scarcely sees the play at all
For watching his reaction to it.
> E.B. WHITE
> 'Critic'

Let dull critics feed upon the carcases of plays: give me the taste and the dressing.
LORD CHESTERFIELD
Letters to his Son, 6 February 1752

When a play is crashingly dull the critic has only two resources. One is sleep in justification whereof I shall quote William Archer's dictum that the first qualification for a dramatic critic is the capacity to sleep while sitting bolt upright.
JAMES AGATE, 1932

If the critics were always right we should be in deep trouble.
ROBERT MORLEY

I go to the theatre to be entertained. I don't want to see plays about rape, sodomy and drug addiction – I can get all that at home.
cartoon caption in the *Observer,* 8 July 1962

My native habitat is the theatre. I toil not, neither do I spin. I am a critic and a commentator. I am essential to the theatre – as ants to a picnic, as the boll weevil to a cotton field.
JOSEPH L. MANKIEWICZ
in the film, *All About Eve,* based on Mary Orr's *The Wisdom of Eve*

Has anyone ever seen a dramatic critic in the daytime? Of course not. They come out after dark, up to no good.
P.G. WODEHOUSE
New York Mirror, 27 May 1955

Maybe they weren't punks at all, but New York drama critics.
> TENNESSEE WILLIAMS on being mugged in Key West, Florida
> *People*, 7 May 1979

You don't expect me to know what to say about a play when I don't know who the author is, do you? ... If it's by a good author, it's a good play, naturally. That stands to reason.
> GEORGE BERNARD SHAW
> *Fanny's First Play, Epilogue*

I don't care what you say about me, as long as you say *something* about me, and as long as you spell my name right.
> actor GEORGE MICHAEL COHAN on himself
> quoted by John McCabe in *George M. Cohan, The Man Who Owned Broadway*

I love criticism just so long as it's unqualified praise.
> NOËL COWARD

Criticism hurt me when I had failures. I thought: 'I'll never write another play.' But I'm an alligator. Only the alligators remain. The others get out of the water.
> ARTHUR MILLER
> quoted in 'Sayings of the Week',
> *The Observer*, 5 April 1987

The Winter's Tale was worthily done, but one gets uncomfortable for the actors when they are surrounded by cubes and cones. You can't quell the fear that if one of them sits on a cone instead of a cube, the blank verse will suffer.
> CLIVE JAMES
> *Observer*, February 1981

When the night's tumult and shouting – much of it for Vivien Leigh – had died, at least one playgoer emerged puzzled by the reputation of a tedious and squalid anecdote … Now and then good writing glimmers, but little to explain the Broadway reputation and run.

> J.C. TREWIN on *A Streetcar Named Desire* by
> Tennessee Williams
> *Observer*, October 1949

The week after – as well as the morning after – I take it to be nothing but a finely acted piece of flapdoodle.

> ALAN DENT on T.S. Eliot's *The Cocktail Party*
> *News Chronicle*, August 1949

John Dexter's production exhibits his usual inspired inattention to detail.

> MERVYN JAMES reviewing Lillian Hellman's *Toys in the Attic* at the Piccadilly Theatre, *London Tribune*, 1960

Mr John Dexter's production consists of a series of pregnant pauses, none of which, unfortunately, are ever brought to bed.

> BERNARD LEVIN on the same production
> *Daily Express*

The play left a taste of lukewarm parsnip juice.
 ALEXANDER WOOLCOTT

A combination of Little Nell and Lady Macbeth.
 ALEXANDER WOOLCOTT
 While Rome Burns

Hook and Ladder is the sort of play that gives failures a bad name.
 WALTER KEIR

The scenery was beautiful, but the actors got in front of it.
 ALEXANDER WOOLCOTT, on *Smart Alex*

House Beautiful is play lousy.
 DOROTHY PARKER

It is three and a half hours long, four characters wide, and a cesspool deep.
 JOHN CHAPMAN on Edward Albee's *Who's Afraid of Virginia Woolf?*
 New York Daily News, 15 October 1962

There is something about seeing *real people* on a stage that makes a bad play more intimately, more personally offensive than any other art form.
 ANATOLE BROYARD
 New York Times, 6 February 1976

As boring as a boarding school on bath night.
 MERVYN STOCKWOOD, Bishop of Southwark, on *Oh! Calcutta, Sunday Times*, 2 March 1980

I have sat through an Italian opera, till, for sheer pain, and inexplicable anguish, I have rushed out into the noisiest places of the crowded streets, to solace myself with sounds which I was not obliged to follow, and get rid of the distracting torment of endless, fruitless, barren attention!

CHARLES LAMB
'A Chapter on Ears', *Essays of Elia*

I love Italian opera – it's so reckless. Damn Wagner, and his bellowings at Fate and Death. Damn Debussy, and his averted face. I like the Italians, who run all on impulse, and don't care about their immortal souls, and don't worry about the ultimate.

D.H. LAWRENCE
in a letter to Louise Burrows, 1 April 1911

It is from Mozart more than any other composer that we can learn the easiest way to understand operatic ideals at their best. Mozart will furnish us with a permanent standard for opera, just as Beethoven does for the symphony and Handel for the oratorio, even although all three belong to an age that is far remote from our own.

E.J. DENT
Mozart's Operas, 1913

No composer – not Verdi, not Wagner, for all their greatness – had Mozart's gift for devising music so close to his characters, or for using music in its greatest variety to underscore the high points in his dramas.

ALAN RICH

The scene is a forest. Wotan rouses the dragon. At first the dragon says: 'I want to sleep.' Then he emerges from the cave. The dragon is represented by two men covered with a green hide with scales attached. The dragon, whose job is to terrify – and doubtless, with children of five, he would succeed – pronounces certain words in a bass voice. It is so silly, so puerile, that one is amazed to see certain big-wigs in the audience ... Here comes Siegfried with his horn. In a pause that is considered very beautiful, he lies down ... He cuts a reed with his sword and makes a flute of it. But he plays the flute badly and falls to blowing the horn. This scene is unbearable. Not the least trace of music. It was exasperating to see, all round, three thousand people listening obediently to this absurdity and admiring it because they thought they ought to. With a courageous effort I managed to stay for the following scene, Siegfried's struggle with the dragon – roars, fire, brandishings of the sword – but after that I could bear it no longer and rushed from the theatre with a feeling of disgust which I have not yet been able to shake off.

> LEO TOLSTOY
> *What Is Art?*

I do not believe that a single composition of Wagner will survive him.

> MORITZ HAUPTMANN
> *Briefe von Moritz Hauptmann*, 3 February 1849

I can confidently and in soberness declare that Wagner is a colossal fraud ... Wagner is the supreme example of the truth that cleverness, even cleverness raised to the nth power of genius, is not enough. All the big scenes in the

Ring sound to my ear so insincere, so hollow, and theatrical that I now find them hardly tolerable. Everything is planned for effect ... Nothing but a blatant bid for theatrical effect.

W.J. TURNER
Facing the Music, 1933

We must really get away from Wagner's idea that in opera the drama has the first claim and the music only the second. He defeated it himself, unwittingly but brilliantly, by writing music which gloriously transcends, for instance, that tautological tetralogy of his, which, had it not been for his towering genius as a composer, the world would long ago have discovered to be unbearable.

ERIC BLOM
A Musical Postbag, Singing in Post-Wagnerian Opera

As I left the State Opera last night, I had a sensation of coming not out of a public institution, but out of an insane asylum ... *Wozzek* by Alban Berg ... I regard Alban Berg as a musical swindler and musician dangerous to the community ... We must seriously pose the question as to what extent the musical profession can be criminal. We deal here, in the realm of music, with a capital offence.

PAUL ZSCHORLICH
Deutsche Zeitung, Berlin, 15 December 1925

After a second performance of the excerpts from *Lulu*, this reviewer is moved to remark that he considers them involved trash ... a score that will not outlast the decade

that gave it birth ... Rapine, suicide, murder, the prevailing flavour of a highly diseased eroticism.
OLIM DOWNER
New York Times, 29 November 1935

Bernard Shaw once sent Churchill two tickets for the opening of his new play, with the invitation: Bring a friend – if you have one. Churchill regretted that he was engaged and asked for tickets for the second performance – If there is one.

One of us is obviously mistaken.
WILLIAM SAROYAN to a critic who had panned his latest play
New York Mirror, 10 June 1960

I am sitting in the smallest room in my house. I have your review before me. Soon it will be behind me.
MAX REGER
to a critic